one hundred:
a sentence

matthew howard

puma concolor aeternus
2016

One Hundred: A Sentence.
© 2016 by Matthew Howard.
All Rights Reserved.

ISBN-10: 1537364049
ISBN-13: 978-1537364049

When

you

started

matthew howard

reading

one hundred

this

100

matthew howard

sentence,

one hundred

you

thought

you

had

a

matthew howard

century,

or

matthew howard

ten

decades,

or

maybe

matthew howard

one

tenth

of

a

matthew howard

millennium—

thirty-six

thousand

five

hundred

and

twenty-five

one hundred

days

to

be

exact—

but

matthew howard

it

turns

out

we

never

have

as

much

time

as

think

we

do,

even

when

hours

drag

or

when

we

just

want

get

matthew howard

over

100

one hundred

with,

100

never

as

much

time

as

we

matthew howard

need

to

finish

that

matthew howard

one

last

thing,

that

final

act

of

one hundred

passion

or

obsession,

the

perfect

coda

to

the

performance

of

a

lifetime,

because

the

ending

matthew howard

will

always

matthew howard

catch

us

completely

by

surprise.

www.ingramcontent.com/pod-product-compliance
Lightning Source LLC
Chambersburg PA
CBHW060357190526
45169CB00002B/642